T0048599

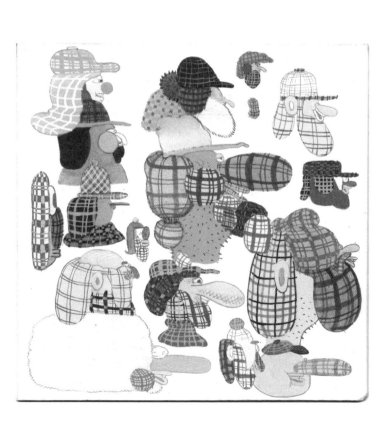

seth scriver's

stooge pile

petits livres
Drawn & Quarterly
Montreal

Entire contents © 2010 by Seth Scriver. All rights
reserved. No part of this book (except small portions for
review purposes) May be reproduced in any form
without written permission from Seth Scriver or
Drawn & Quarterly. Drawn & Quarterly acknowledges
the financial contribution of the Government of
Canada through the Book Publishing Industry Devel-
opment Program (BPIDP) and the Canada Council for the
Arts for our publishing activities and for support
of this edition.

Drawn & Quarterly
Post Office Box 48056
Montreal, Quebec
Canada H2V-4S8
www.drawnandquarterly.com

First softcover edition: February 2010
Printed in Canada
10 9 8 7 6 5 4 3 2 1

Library and Archives Canada
Cataloguing in Publication

Scriver, Seth
Stooge pile/Seth Scriver.
ISBN 978-1-77046-005-8

1. Scriver, Seth. I. Title
PN6733.S38S76 2009 741.5'971
C2009-906025-6

Distributed in the USA by:
Farrar, Staus and Giroux
18 West 18th Street
New York, NY 10011
Orders: 888.330.8477

Distributed in Canada by:
Raincoast Books
9050 Shaughnessy Street
Vancouver, BC V6P 6E5
Orders: 800.663.5714

CONTENTS

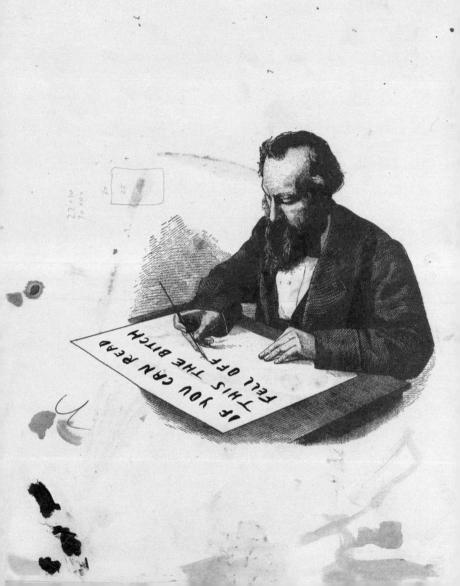

WAL★MART
WE SELL
FOR LESS
DUFFERIN 3106
ST# 3106 OP# 00003352 TE# 17 TR# 06653
PSYCHO STROB 078843218212 15.96 E
PSYCHO STROB 078843218212 15.96 E
PSYCHO STROB 078843218212 15.96 E
STROBE 078843218181 15.96 E
PSYCHO STROB 078843218212 15.96 E
PSYCHO STROB 078843218212 15.96 E
STROBE 078843218181 15.96 E
PSYCHO STROB 078843218212 15.96 E
PSYCHO STROB 078843218212 15.96 E
STROBE 078843218181 15.96 E
PSYCHO STROB 078843218212 15.96 E
PSYCHO STROB 078843218212 15.96 E
STROBE 078843218181 15.96 E
PSYCHO STROB 078843218212 15.96 E
PSYCHO STROB 078843218212 15.96 E
STROBE 078843218181 15.96 E
PSYCHO STROB 078843218212 15.96 E
PSYCHO STROB 078843218212 15.96 E
STROBE 078843218181 15.96 E
PSYCHO STROB 078843218212 15.96 E
PSYCHO STROB 078843218212 15.96 E
STROBE 078843218181 15.96 E
PSYCHO STROB 078843218212 15.96 E
PSYCHO STROB 078843218212 15.96 E
PSYCHO STROB 078843218212 15.96 E
STROBE 078843218181 15.96 E
PSYCHO STROB 078843218212 15.96 E
PSYCHO STROB 078843218212 15.96 E
PSYCHO STROB 078843218212 15.96 E
STROBE 078843218181 15.96 E
PSYCHO STROB 078843218212 15.96 E
PSYCHO STROB 078843218212 15.96 E
PSYCHO STROB 078843218212 15.96 E
STROBE 078843218181 15.96 E
PSYCHO STROB 078843218212 15.96 E
PSYCHO STROB 078843218212 15.96 E
PSYCHO STROB 078843218212 15.96 E
STROBE 078843218181 15.96 E
PSYCHO STROB 078843218212 15.96 E
PSYCHO STROB 078843218212 15.96 E
STROBE 078843218181 15.96 E
PSYCHO STROB 078843218212 15.96 E
PSYCHO STROB 078843218212 15.96 E
1.5X2 FLUORE 002120059018 2.27 E
PSYCHO STROB 078843218212 15.96 E
STROBE 078843218181 15.96 E
PSYCHO STROB 078843218212 15.96 E
PSYCHO STROB 078843218212 15.96 E
STROBE 078843218181 15.96 E
 SUBTOTAL 577.00
 GST 7% 40.44
 PST 8% 46.22
 TOTAL 666.66
 DEBIT TEND 666.66
 CHANGE DUE 0.00
GST/HST 137466199 RT 0001
QST 1016551356 TQ 0001

PURCHASE TRANSACTION RECORD
 666.66
CHEQUING **************2012 - 0001
RRN # : 016000039
AUTH #: 159588
00 APPROVED-THANK YOU
TERMINAL ID: WALCAADBFBU
 06/06/06 66:66:39

ITEMS SOLD 66
TC# 6200 0811 3636 3318 0527 6

We Sell For Less, Everyday!
 06/06/06 16:00:42

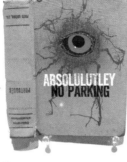

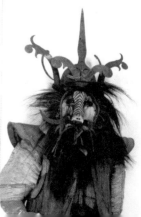

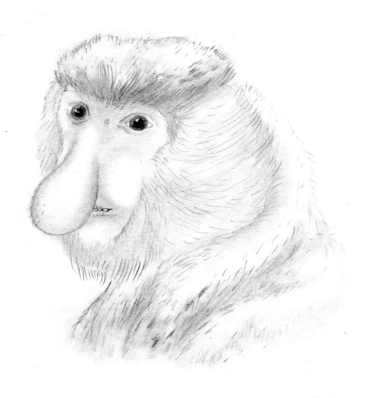

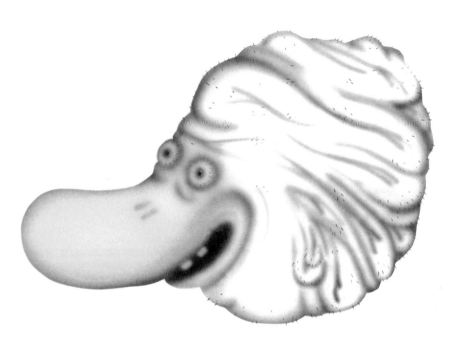

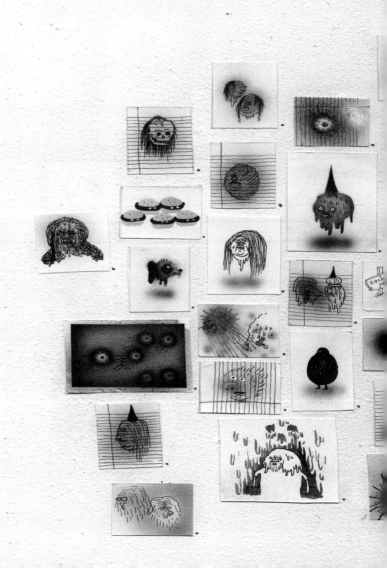

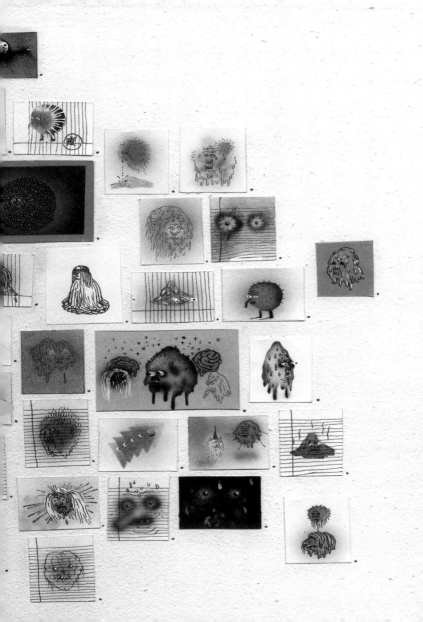

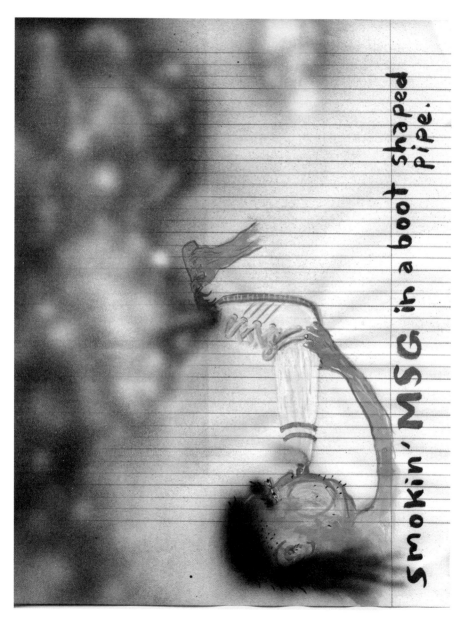

Smokin' MSG in a boot shaped pipe.

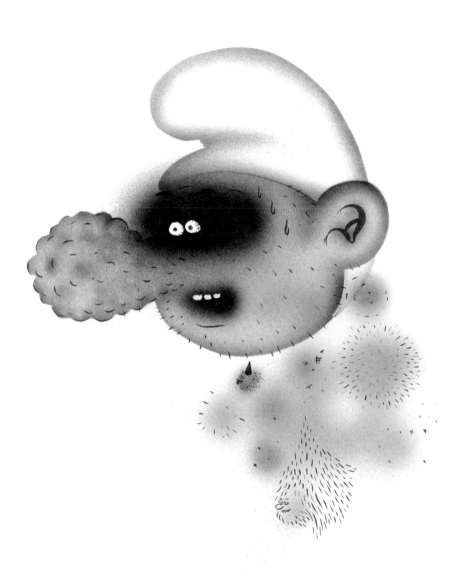

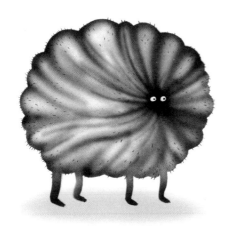

MUSH MUSH MUSHAWAY

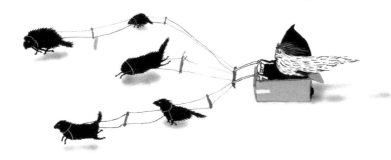

FUCK FUCK FUCK OFF

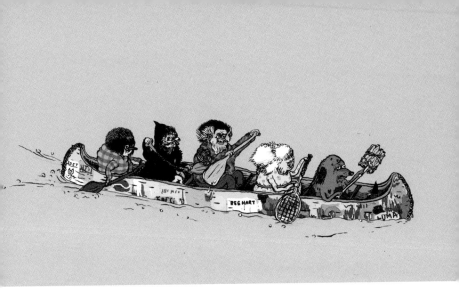

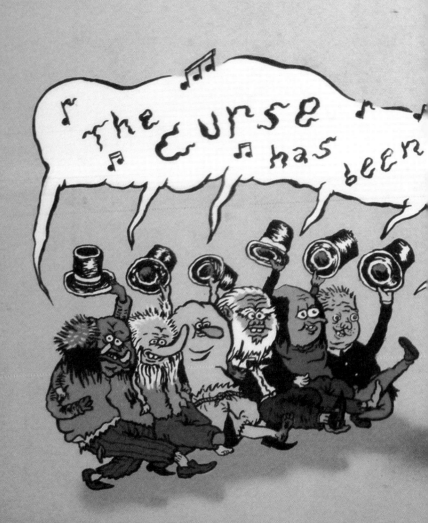

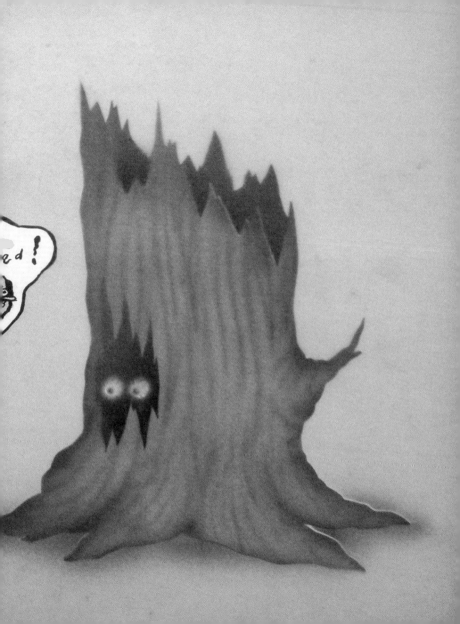

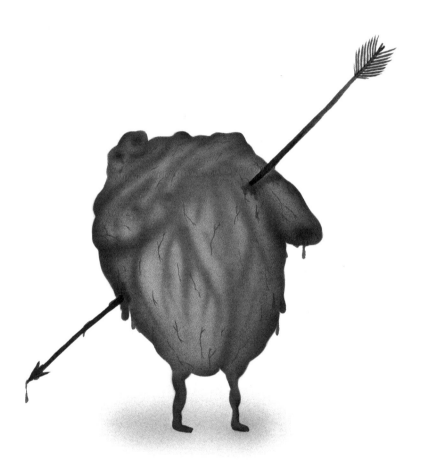

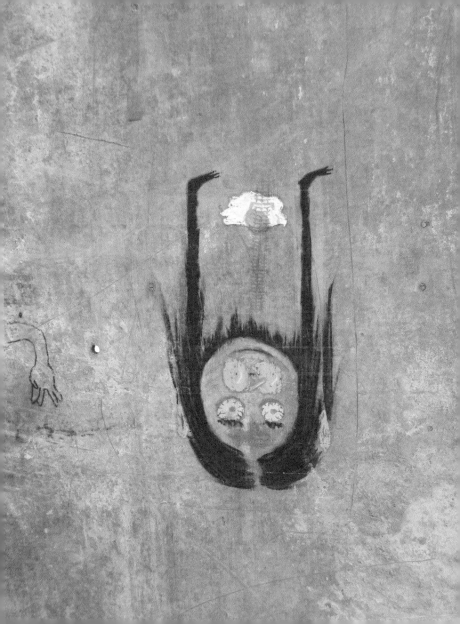

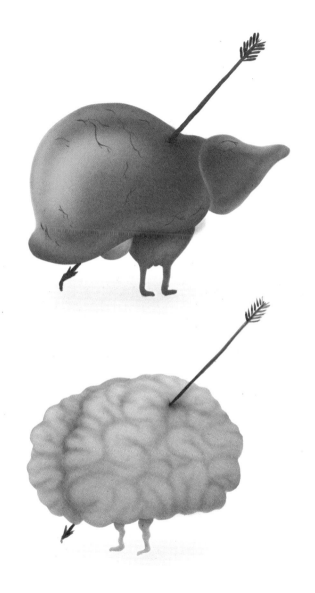

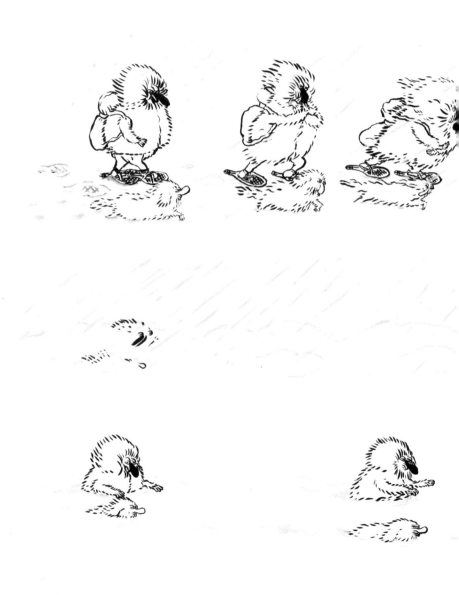

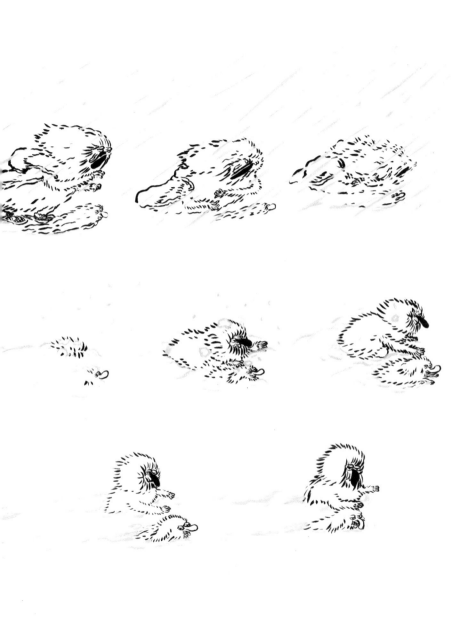

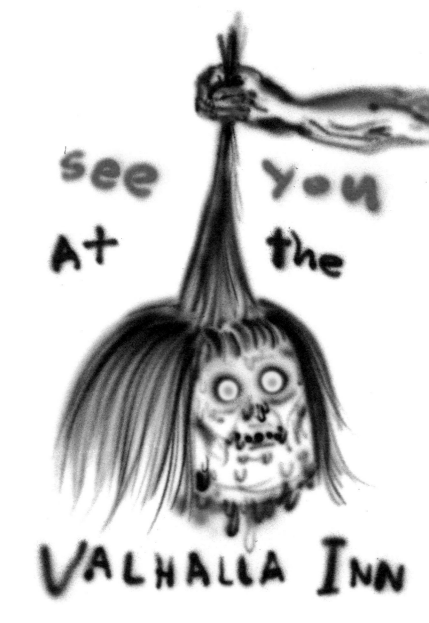

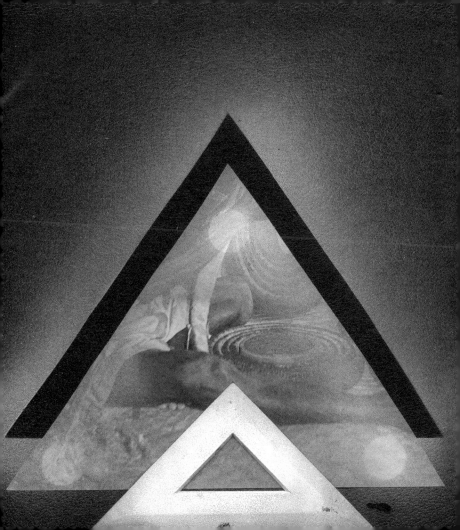

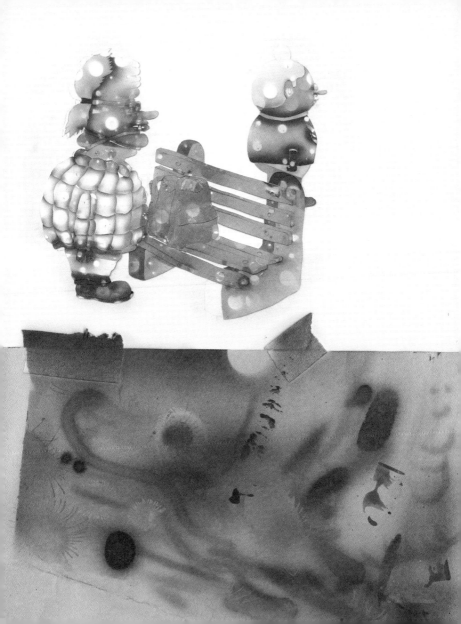

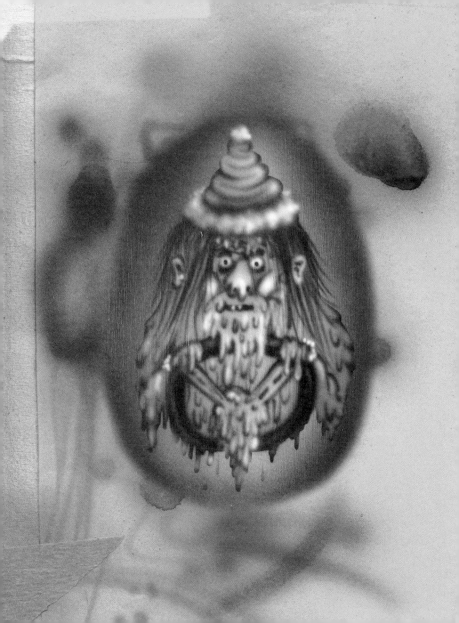

Intermission

brought to you by
the Paper Museum

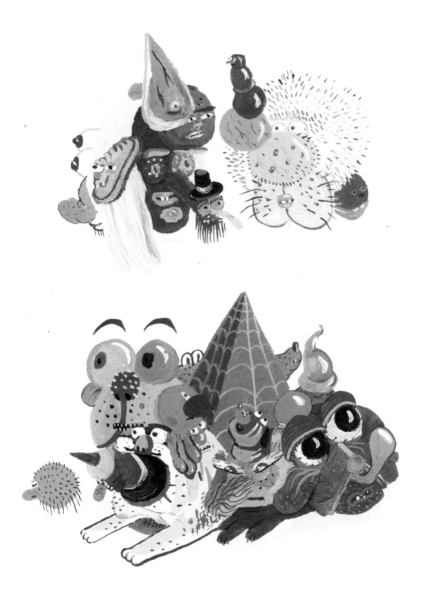

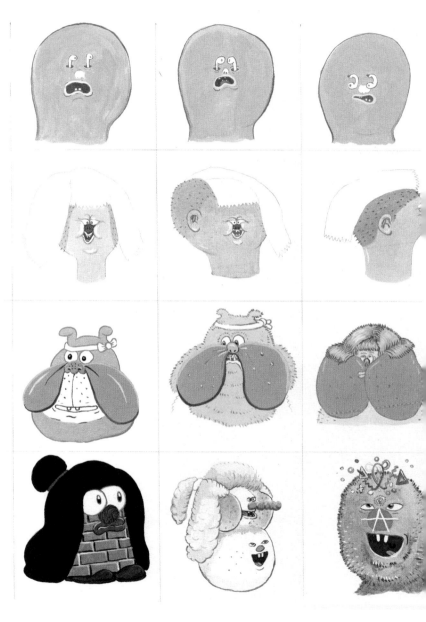

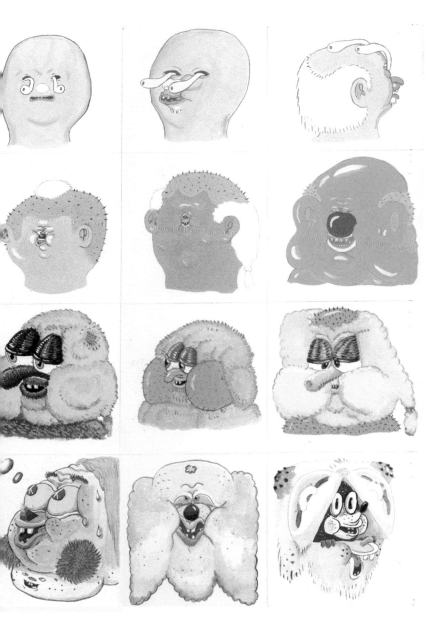

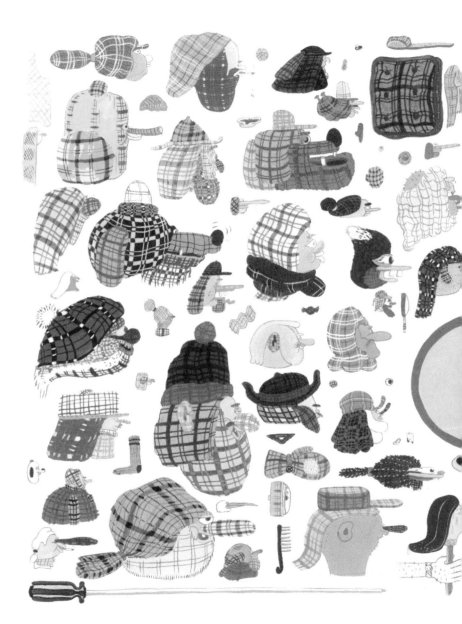

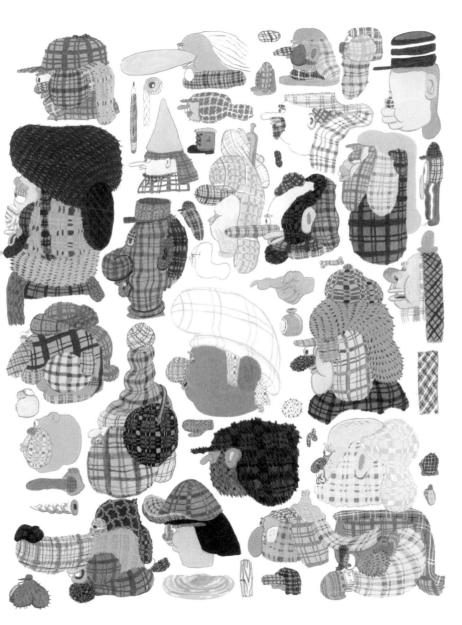

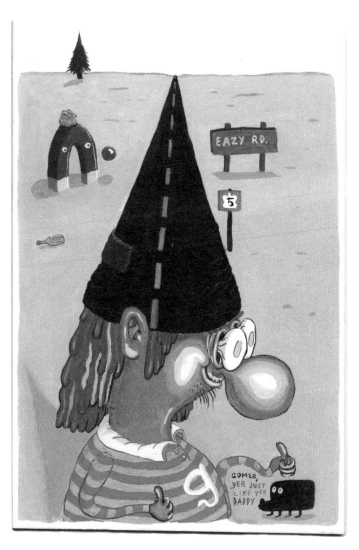

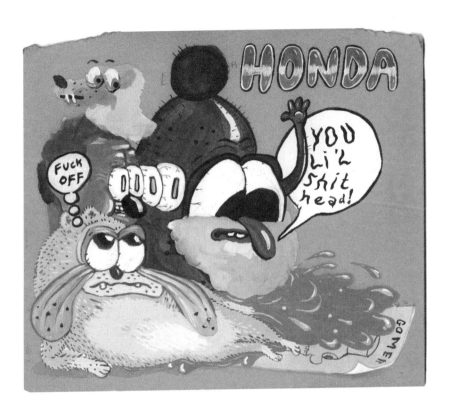

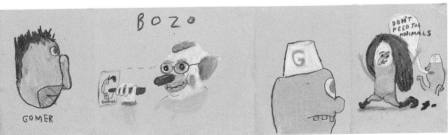

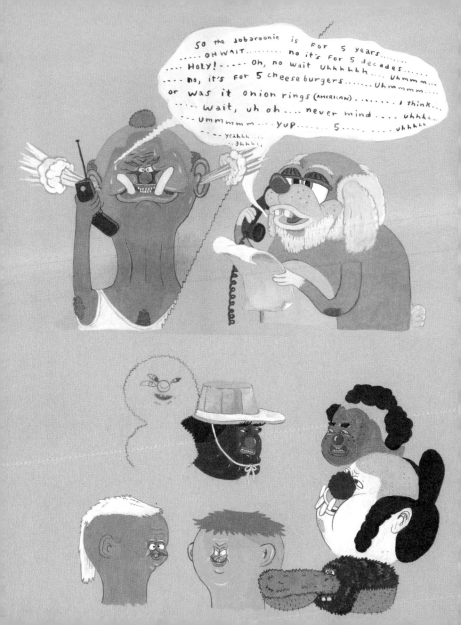

CONTRACT

NO
ASSHOLES

x ~~*asshole*~~

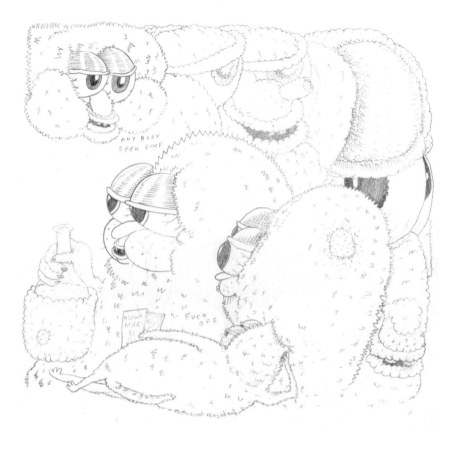

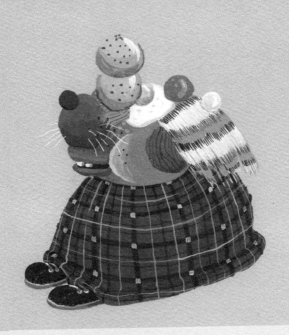

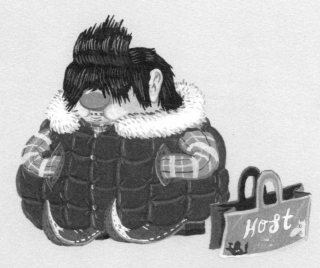

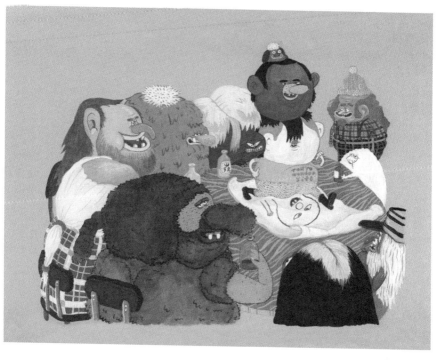

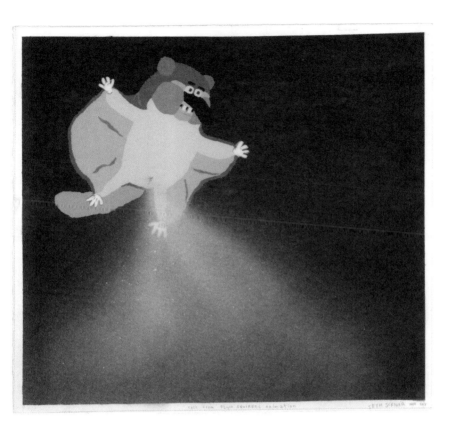

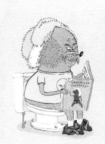

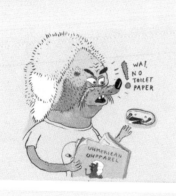

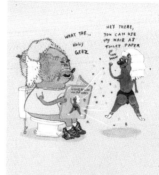

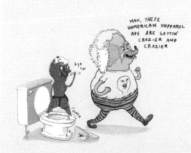

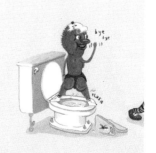

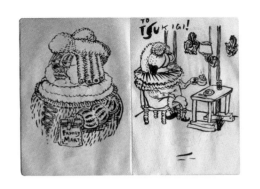

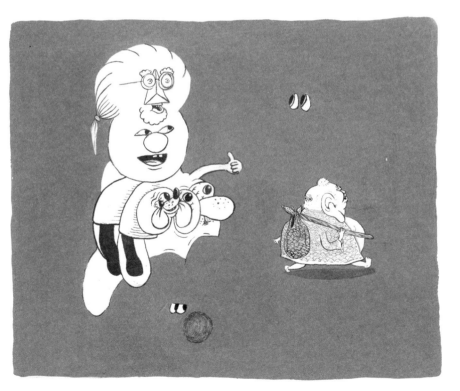

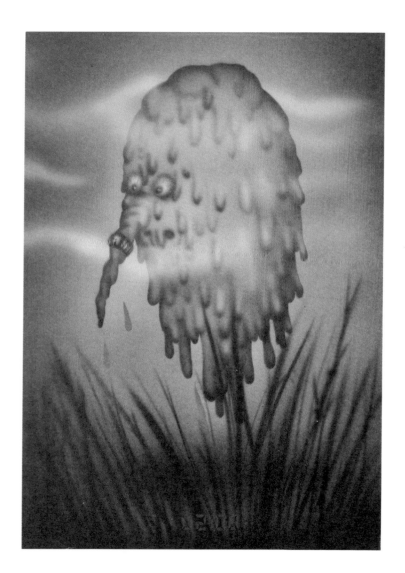

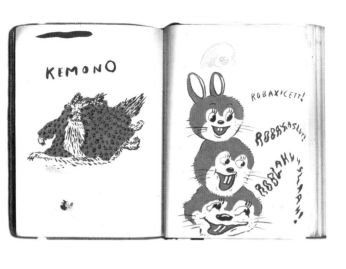

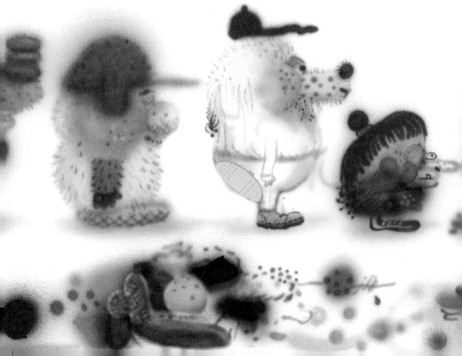

do it yourself

section

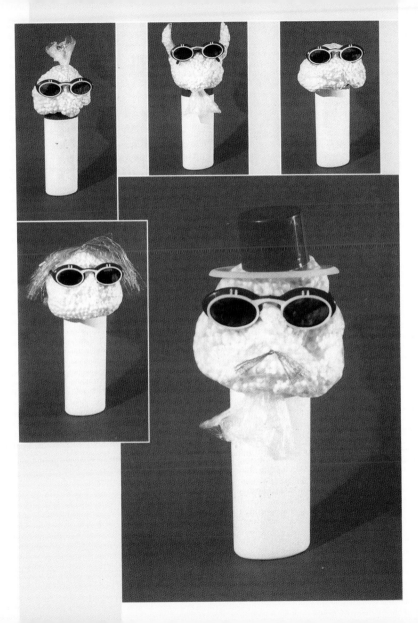

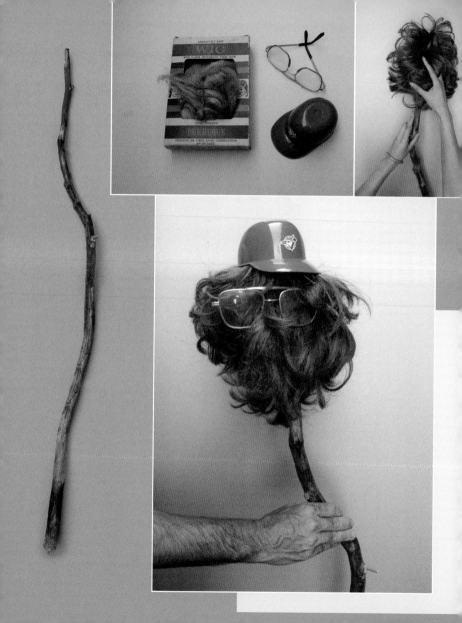

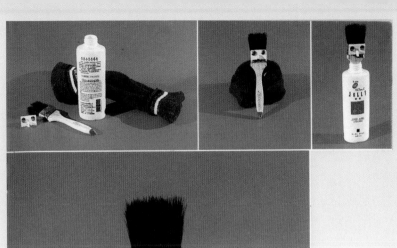

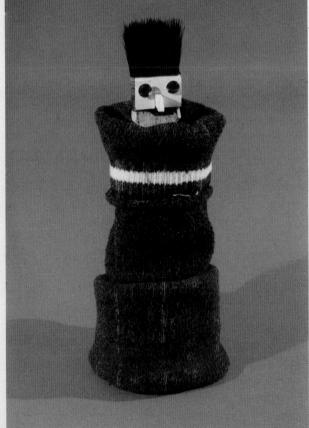

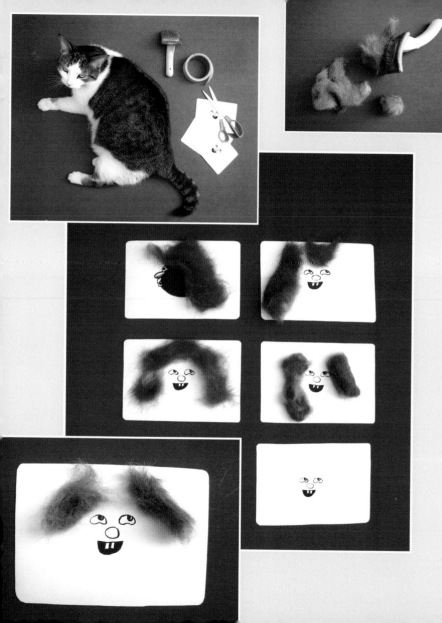

PORTRAITS

- ☒ Bird Lady w/CARRY-OKAY
- ☐ Bird Lady w/tri Scooter
- ☒ Totally blown winter Fashion studies
- ☒ Chairman of the bored at lola's
- ☐ Strap master
- ☐ (CARROT MIC) Jenny
- ☐ Bird girl (pidgeon SQUEEZER)
- ☐ Cat lady
- ☐ dog men
- ☒ Jenny's
- ☒ B.F.G.'s Bunchafuckingoofs
- ☐ Blind flute web traveller
- ☐ Fish mongers
- ☐ Quadrokeyboardist
- ☐ Terrible Banhu Player
- ☐ Zombies (krackies)
- ☐ Witch doctors
- ☐ BUTT CHOPS
- ☐ FOOFY
- ☐ H-DOG
- ☐ charlie SUPAH ANNNIMAL!
- ☐ I KNOW WHY NO WINO's

- ☐ LUCKY TRO & THE BOYS
- ☐ Rasta Warrior
- ☐ PROsthetic Finger nail Sniper
- ☐ PATTY DREAD KING
- ☐ TATTY
- ☐ The Post Postman
- ☐ CAT POST (skeleton hat)
- ☐ NERVOUS hippie
- ☐ MATT GUY
- ☐ Ancient Leather man (straight leg walker)
- ☒ Nearly naked greased up bulbous scooter rider w/yoga mat
- ☐ PROBISCUS monkey
- ☐ old man pigtails
- ☐ poster kid with snow suit on
- ☐ ▬▬▬ Almost
- ☐ bottle bottle/can can's
- ☐ shitty jeans NARC
- ☒ ELASTIC BAND FACE MAN & BUMP ON YOUR HEAD
- ☐ curly
- ☐ Euro-dee Cops
- ☐ MOSES THE LADY Lover
- ☐ HEAD ON SIDE WAYS MAN
- ☒ The Luddite (stop the city)
- ☒ CN TOWER STUMP

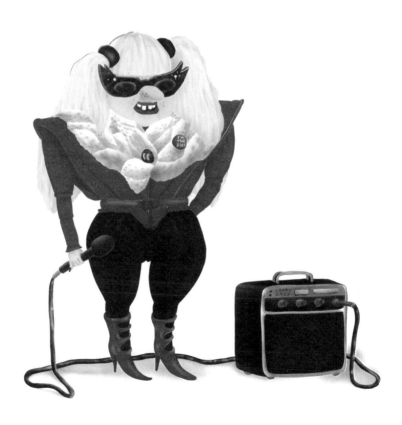

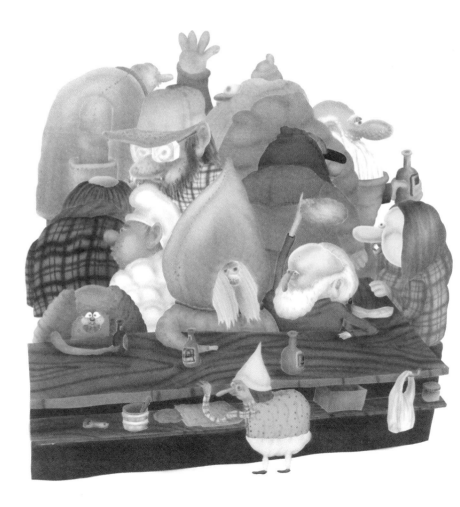

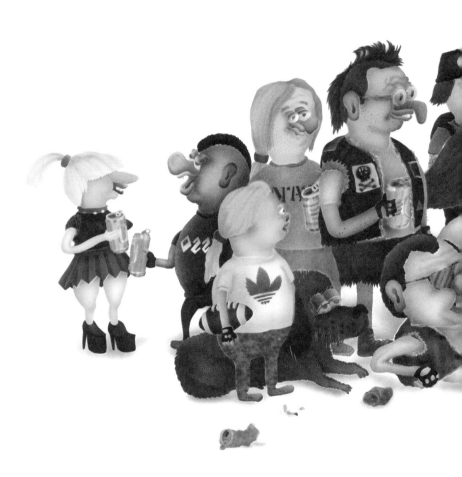

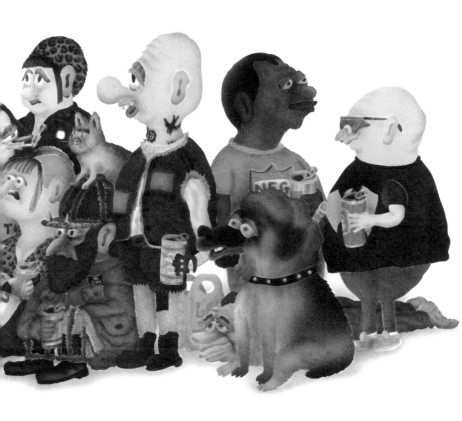

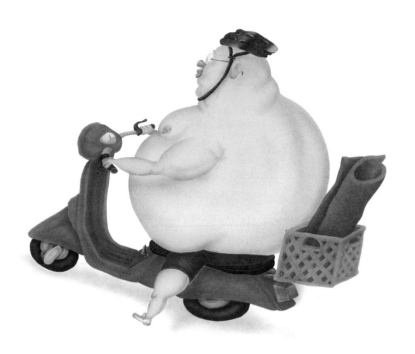

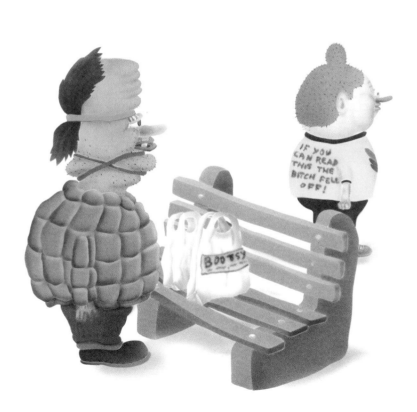

Stop
the
City

"Absolulutely NO PARKING" is a TRADE MARK OF SANDY Plotnikoff.

-The four pink drawings in the Japasneezer section are by Marc Bell and the scrive dog.

- Also The contract negotiating DOG DIALOG WAS EDITED BY BEE BOY!

A SPECIAL THANKS goes out to

- AMY C. LAM
- BELLY BOY
- Smootie PANTS
- ESS PEE
- LAM CHOPPS
- THE H-dog
- B$_x$F$_x$G$_x$'s
- the COUNTACHE
- Smear balls
- delusional bro. Ink.
- BOBBIN & Ronnie
- KiKi
- KROPO FAMILY

- BIRDOFLUGAS
- the Scrivers
- KENICHI & LORA
- UNCLE MIKE
- the EGG LADY
- FOOFY
- the bird Lady
- dog Lyds
- KING COMER
- the GOD OF SATURNALIA

AND TOM

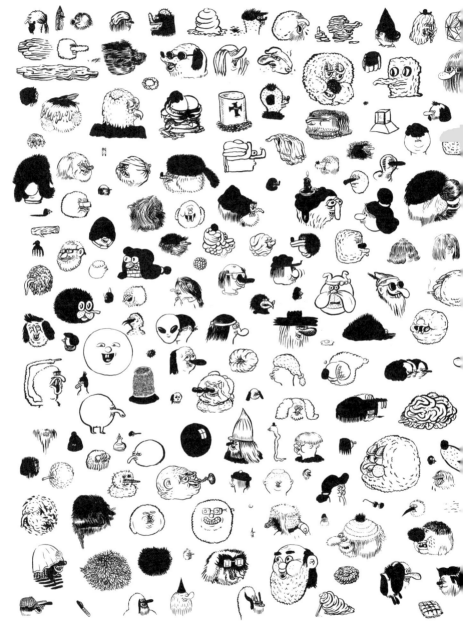